Lenore Tawney

Signs on the Wind

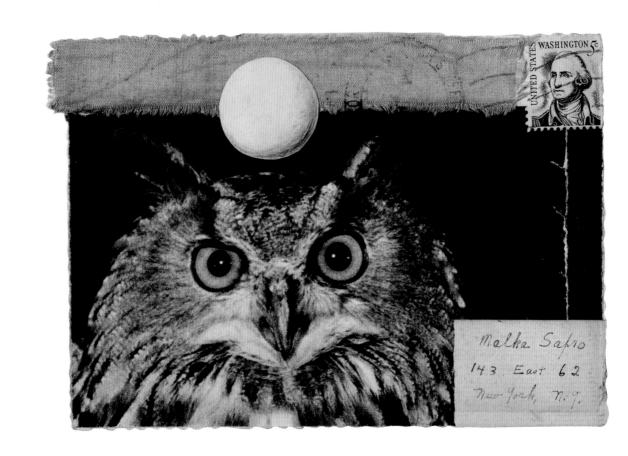

Lenore Tawney
Signs on the Wind

LENORE TAWNEY
POSTCARD COLLAGES

ESSAY BY HOLLAND COTTER
PHOTOGRAPHY BY GEORGE ERML

Pomegranate
SAN FRANCISCO

Published by Pomegranate Communications, Inc.
Box 6099
Rohnert Park, California 94927
1 800 227 1428; *www.pomegranate.com*

Pomegranate Europe Ltd.
Fullbridge House, Fullbridge
Maldon, Essex CM9 4LE, England
44 1621 851646

© 2002 Lenore Tawney
Text © 2002 Holland Cotter

Half title page: Lenore Tawney working on *Waters above the Firmament* (detail), Wooster Street studio, 1976. Linen, manuscript, Liquitex, 156$\frac{1}{2}$ x 145$\frac{1}{4}$ in.

Images on pages 29 through 36 courtesy The Cleveland Museum of Art: p. 29, Granatapfel, 1981.171; p. 30, Giraffe, 1981.170; p. 31, King of Beasts, 1981.186; p. 32, Little Girl, 1981.185; p. 33, Heart, 1981. 163; p. 34, Eskimo, 1981.203; p. 35, Fist, 1981.180; p. 36, Calligraphic Message, 1981.193

Library of Congress Cataloging-in-Publication Data

Tawney, Lenore.
 Lenore Tawney : signs on the wind—postcard collages / essay by Holland Cotter.
 p. cm.
 ISBN 0-7649-2130-4 (alk.paper)
 1. Tawney, Lenore—Catalogs. 2. Collage—United States—Catalogs. I. Cotter, Holland,
 1947- II. Title

N6537.T38 A4 2002
709'.2—dc21 2002066245

Pomegranate Catalog No. A639
ISBN 0-7649-2130-4

Cover and interior design by Harrah Lord

Printed in China

11 10 09 08 07 06 05 04 03 02 10 9 8 7 6 5 4 3 2 1

LENORE TAWNEY:
POSTCARD TO THE WORLD

THE POET Emily Dickinson was an avid correspondent, and people were always thrilled to hear from her. They tended to treat her notes and letters as works of art, reading and rereading them, preserving them, passing them on; that's why so many have survived. The letters were important for Dickinson, too. They were a place where she could play with images and ideas in ways the taut, knotted structures of poems did not really permit. In addition, letters kept her in touch with the world, and the world in touch with her, from a distance.

When Dickinson was young, her letters were long, episodic, and searching; as she grew older they became short and epigrammatic. Her methods of sending them varied. She personally delivered notes to her sister-in-law and next-door neighbor, Susan Dickinson, in a quick meeting on the lawn or in a hallway. Other letters went out through the U.S. mail. I suspect Dickinson liked the idea of the postal service, as she did other routine, well-regulated, hands-on American things, like seasonal harvests, train schedules, and village lamplighting.

Dickinson famously referred to her poetry as a "letter to the world," and she often included drafts of her poems in letters. Some letters are themselves poems. Read aloud, they reveal a verse rhythm, its strophic beat indicated by dashes. The various "voices" she used in her poetry—of concerned friend, humble disciple, precocious child—surface in the letters too, along with private codes that only longtime Emily-world residents understood. "Emily sends her love!" a reader might casually call out to her inattentive family as she finished a letter and stashed it away for safekeeping. But Dickinson had sent much more than that: herself—her wit, her curiosity, her shy generosity, her miniaturist gift for grandeur.

So that was Emily Dickinson, and now we're talking about Lenore Tawney, also American, also reticent, also a correspondence-artist. The differences between the two women are, of course, many. Tawney is a modern city-dweller who has traveled widely and changed residences repeatedly. Dickinson spent her life in a small, rural New England town and seldom left her family home. There are also similarities. Like Dickinson, Tawney shaped an art that reconfigured the definition of monumental. Dickinson created tiny poems on immense subjects; Tawney, in her floor-to-ceiling woven pieces of the 1950s and 1960s, turned an intimate craft medium into towering sculptures.

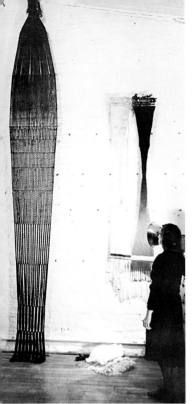

Lenore Tawney with *Dark River,* 1962, South Steet studio. Linen, wood, 163 x 22½ in. Collection The Museum of Modern Art, New York, Greta Daniel Design Fund.

In addition, there are serendipitous personal links. Late in her life, Dickinson dressed mostly in white, a kind of monastic uniform that both neutralized what-should-I-wear personal vanity and probably showed off her auburn hair to advantage. Tawney lives in an all-white Manhattan loft, where her collection of globe-spanning objects—Hindu devotional paintings, Native American baskets, Japanese ceramics, and examples of her own weavings, assemblages, and collages—are ideally framed and sum up a widely traveled interior life.

Lenore Tawney was born Leonora Gallagher in Lorain, Ohio, in 1907, of Irish and Irish-American stock. As a child she attended "parochial" schools. (Dickinson did too, although her schools were Calvinist, not Roman Catholic.) At age twenty, she moved to Chicago, where she worked as a proofreader by day and studied art at the Art Institute of Chicago at night. In 1941, she married a young psychologist named George Tawney, who died suddenly a

year and a half later. In 1946, after a period of personal uncertainty, she enrolled at the Chicago Institute of Design. Its Bauhaus aesthetic awarded fine art and craft equal status, and she had fabulous teachers: Alexander Archipenko for sculpture, Laszlo Moholy-Nagy for drawing, Marli Ehrman for weaving.

At first, sculpture seemed to be the medium Tawney would pursue—she accepted Archipenko's invitation to work in his Woodstock, New York, studio—but it didn't work out for her at the time. The medium as she was practicing it seems to have been physically too demanding,

Lenore Tawney, 1962, Beekman Street studio.

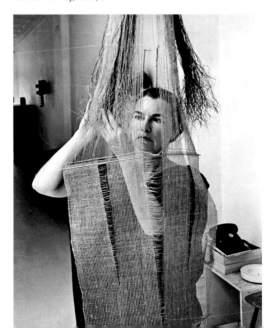

although possibly she felt discomfort with some of the modernist thinking attached to it, which left little room for eclecticism, experimentation, and eccentricity. Whatever the reason, she left making sculpture, went to Europe, and waited to see what would happen next.

What happened, or what happened again since Tawney had been introduced to it earlier, was weaving. In 1954, she studied weaving with Martta Taipale at the Penland School of Crafts in North Carolina and soon made it her own by developing a distinctive open-warp technique that was basically like drawing or painting with individual, floating threads while leaving much of the fabric unwoven and transparent. Although the results found passionate admirers, Tawney's work was considered heretical by orthodox craft adherents, but too "craftsy" by the orthodox art world, an attitudinal divide that has never been fully resolved. (The Museum of Modern Art has collected her work, but Tawney's gorgeous 1990 career retrospective was presented at the American Craft Museum across the street.)

Tawney was almost fifty when she made her major formal and conceptual leap and began her true career. She *was*

fifty when she made her most radical geographic move, to New York City in 1957. New York was, of course, the center of the advanced postwar art world, and because Tawney identified herself as an advanced postwar artist, it was where she wanted to be. The move also represented a fresh, swept-clean personal start at the moment artwork was bearing full fruit.

Tawney was lucky to land where she did in the city: in a district of early nineteenth-century loft buildings between Wall Street and the South Street Seaport in Lower Manhattan. There she settled in a cold-water loft on Coenties Slip, a bare-bones affair with no amenities but lots of space and marvelous views of the harbor. Another plus: the superintendent was a young painter named Jack Youngerman, fresh from several years in France and with friends living nearby. The Slip, it turned out, was an unofficial artists' community, one isolated, but not insulated, from the buzzing art scene uptown. Ellsworth Kelly, Robert Indiana, and Agnes Martin were among Tawney's immediate neighbors; Barnett Newman had a studio a few blocks away.

At Coenties Slip, Tawney forged a particularly close bond

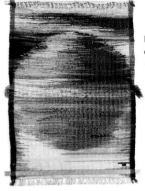

Lenore Tawney, *Jupiter*, 1959. Wool, silk, 53 x 41 in. Collection American Craft Museum, New York. Gift of the Johnson Wax Company, from Objects: USA. Photograph courtesy Richard DiLiberto.

with Martin, who was close to her own age. The two shared intellectual, personal, and artistic interests and provided a sounding board for each other's work. Tawney created names for Martin's abstract paintings; Martin did the same for Tawney's weavings, and she wrote a short brochure essay for Tawney's first major New York solo show, at the Staten Island Museum. "To see new and original expression in a very old medium," Martin wrote, "and not just one new form but a complete new form in each piece of work, is wholly unlooked for, and is a wonderful and gratifying experience."

Martin knew that Tawney's weavings were extraordinary; they still look that way, from the beautiful 1959 *Jupiter*, with its shimmery lavender sphere like a mandala under moving water, to the majestic, twelve-foot-high *King I* (1962), its vertical, harp-shaped halves separated by empty space in an almost violent image of tension and unity. Over the next several years Tawney's work continued to grow in size, culminating in the room-filling *Waters above the Firmament* (1976) and the installation of thousands of loose-hanging knotted threads titled *Cloud Series* done the following year, when she was seventy.

At this point Tawney pulled back from monumental projects and turned her full attention to the other, smaller-scale work she had been doing in parallel with her weaving for years. This included elaborate multidimensional collages and sculptural assemblages incorporating such diverse items as feathers, stones, bones, buttons, birds' eggs, shells, dried plants, and pre-Columbian beads. Most concentrated of all were the postcard-size collages that she had been making for friends and family since at least the early 1960s.

In fact, these collages actually functioned as postcards. They were regulation size and sent through the mail without protective covering, in only rare instances with instructions for special treatment, such as hand stamping. Tawney trusted

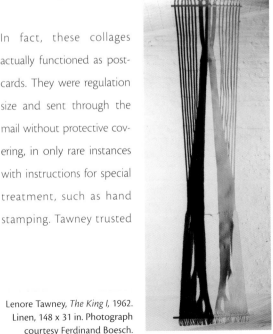

Lenore Tawney, *The King I*, 1962. Linen, 148 x 31 in. Photograph courtesy Ferdinand Boesch.

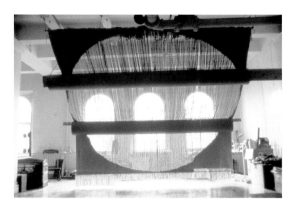

Lenore Tawney, *Waters above the Firmament*, 1976. Linen, manuscript paper, Liquitex, 156 1/2 x 145 1/4 in. Wooster Street studio. Collection The Art Institute of Chicago. Harriott A. Fox endowment; Mrs. Siegfried G. Schmidt Endowment; H. L. and Mary T. Adams Endowment; restricted gift of the Textile Society of The Art Institute of Chicago; Laurance H. Armour Jr. and Margot B. Armour Family Foundation; Mrs. William B. Swartchild Jr.; Joan Rosenberg; Joseph Fell (1983.203).

Lenore Tawney installing *Cloud Series VI*, 1981. Canvas, linen, 16 x 32 x 8 feet. Frank J. Lausche State Office Building, Cleveland, Ohio.

that the collages would be respectfully handled and carefully processed, and they were.

Mailing also served a formal function. Tawney considered the postmark itself an essential collage element. Like the stamp on a passport, it was a concrete, when-and-where record of a journey successfully made. It was so important a component that she mailed even collages she intended to keep for herself: in 1980, she addressed one to her own home in care of "Sarah Jennings," the maiden name of her mother who had died in 1975.

Although certain collages had three-dimensional elements, most were made entirely of paper. In Tawney's wide-ranging and welcoming work, paper encompassed photographs, newspaper clips, magazine ads, cosmological charts, tantric symbols, anatomical diagrams, popular devotional pictures, musical scores, illustrations from art history books and nature guides, antique manuscript pages in languages from French to Sanskrit to Chinese; letters from friends, postcards received and recycled, as well as drawings and notes written in her own hand.

Many collages were designed with particular recipients in mind, among them the critic and curator Katherine Kuh; Tawney's brother Jim; and her friends, Diana Epstein and

Millicent Safro, proprietors of a thread and button shop named Tender Buttons on Manhattan's Upper East Side. By now, years after the collages were made and sent, their embedded personal references may be all but unrecoverable. But that was never the real point of them anyway. The attraction of the collages is not their inscrutability but their accessibility, their fleet wit, their conceptual ingenuity, their stimulating metaphoric play.

You can get a sense of all this with a quick scan of the postcards reproduced in this book, throughout which particular images recur with variations-on-a-theme regularity. Animals, wild and domestic, are often in evidence, from giraffes and zebras to the housecats Tawney has always lived with (until recently the tender Angel, and now the irrepressible Michigan). Some are specially outfitted for their appearance—Tawney gives one cat high heels, another penciled-on eyeglasses—but most are self-sufficient and utterly self-possessed, superior beings.

Birds of all varieties, from confusing-fall warblers to raptors, are everywhere, as they always have been in Tawney's work, from a 1954 weaving titled *St. Francis and the Birds* to a 1990 postcard collage in which the artist

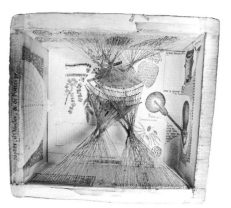

Lenore Tawney, assemblage, c. 1967. Photograph courtesy Clayton Price.

depicts herself metamorphized into an owl. Whatever they may signify, birds have a talismanic presence for Tawney, as does the emblem of the bird's egg, seen as paper cutouts on postcards or as actual objects in assemblages. Fragile but resilient, self-enclosed but rich with potential life, they are like emblems of the art to which Tawney has devoted her life.

Not that the human presence is missing from Tawney's work. It is there in the collages, but handled with a kind of arm's-length critical amusement. One notices, for example, that while she routinely uses photographed images of live birds, she lifts the human figure from art history illustrations or fashion advertising. It is as if, on some private scale of evolution, the former were "realer," or at least more natural, than the latter, a perfectly plausible point of view. "Human" faces in the collages are often those of masks and dolls or likenesses printed on postage stamps, which is how

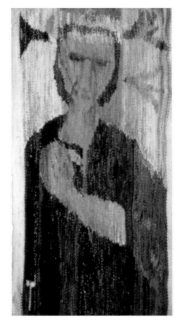

Lenore Tawney, *St. Francis and the Birds*, 1954. Wool, 32 ¹/₂ x 17 ¹/₂ in.
Photograph courtesy George Erml

Albert Einstein and Dwight D. Eisenhower come into the picture. Figures that are borrowed from fashion spreads or from magazine ads tend to be drastically cropped and edited, cut into abstract parts. Tawney reduces one model to little more than a nose; another has her face replaced by a planetary sphere. In some cases, only clothing is shown, as in a series of "shoe" postcards sent to Paul Smith, director emeritus of the American Craft Museum, when he was organizing a show on the theme of the foot.

Tawney's satire can be suprisingly shrewd and funny, as it is with the subject of masculine self-aggrandizement. On one card, she pairs a postage stamp image of the domed Capitol Building in Washington with the image of a large, vividly colored phallic mushroom that seems to be slumping on its side like an Oldenberg soft sculpture. In a card sent to the New York artist Robert Kushner, she transforms the same dome into a combination of breast and baby's bottle with a few strategic pen strokes. And in a card to Katherine Kuh, the Capitol becomes the target of a crowd of upraised arms, while a fisted hand—a woman's, I think—blasts right out of the center of the composition.

Whether Tawney meant the hand to be taken as her hand is impossible to say, but there's no question that in general she treats her own image in the collages with inventive self-amusement. In one case, she adds her photographed face to a dazzling icon of a Byzantine saint; in another she gives herself a cosmetic makeover by substituting the head of a pretty woman from a Roman fresco for her own. One of the few portraits left unaltered is that of Tawney's spiritual mentor, Swami Muktananda, whose face simply floats, smiling, in neutral space.

In short, Tawney's postcards are rich, dynamic things. They develop a range of difficult themes—childhood, female sexuality, spirituality—in subtle ways. They can be treasured both for their hermetism and their wide cultural embrace. They can be read as treatises or as valentines. And "reading" is literally what they invite. Every collage is

ornamented with words, in addresses, postmarks, stamps, inscriptions, printed texts. Many of the words are hard, if not impossible, to decipher: the manuscript pages Tawney uses are often in arcane languages and antique scripts; her own handwriting is sometimes so small as to be a species of micrography, with words and phrases spun out as little more than threads of black ink.

In the end, those words and phrases are part of the weave of communicative patterns that Tawney has focused on devotedly for many decades and in many forms, grand and intimate. In a 1971 collage, a slender line of miniscule text runs around the perimeter of a perfect, mandala-like circle on the left side of the card. Affixed to the card at the very center of the circle is the tiny pale carapace of a hermit crab. Tawney sent the card from Truro, Massachusetts, on Cape Cod, and it arrived intact on East 4th St. in New York City.

A miracle? Yes and no. One can imagine the postal workers, first in the small town, then in the city, being puzzled but charmed by Tawney's little journeying gift, setting it aside, making sure it isn't crushed, bringing it intact to its destination. And maybe a spirit who understood the difficulties and delights of sending the self out into the world was keeping watch. In the postcard's upper right corner Emily Dickinson's portrait appears on a commemorative stamp.

Holland Cotter

Lenore Tawney, 1991. Photograph courtesy Eric Boman.

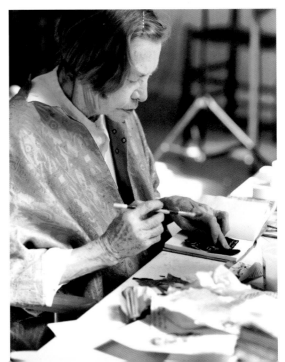

POSTCARD COLLAGES
1961–1990

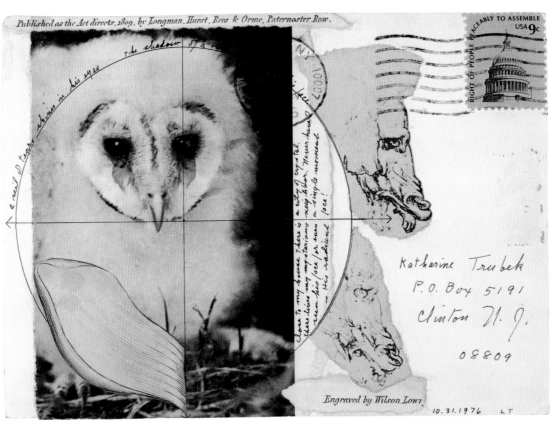

Published as the Act directs, 1809, by Longman, Hurst, Rees & Orme, Paternoster Row.

Engraved by Wilson Lowry

Katharine Trubek
P.O. Box 5191
Clinton N. J.
08809

10.31.1976 LT

FRONT

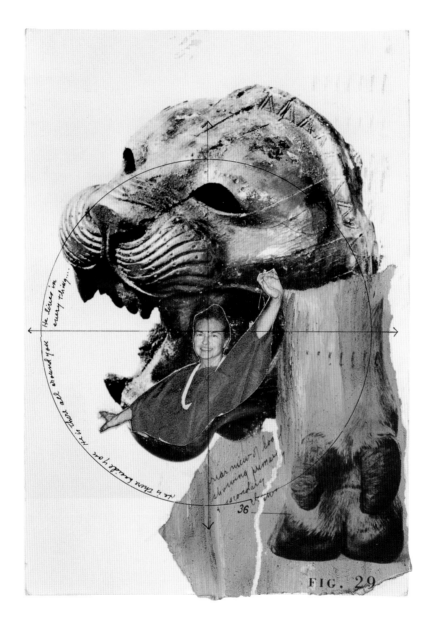

FIG. 29

BACK

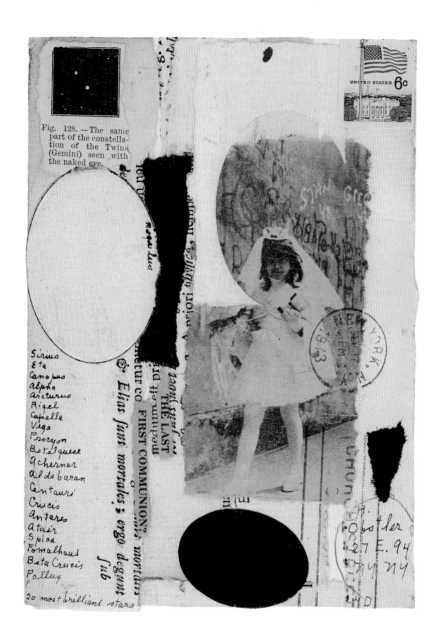

GUATEMALA
-1 IV 74
CENTRO AMERICA

Tender travelers into
the land of Tikal the
land of
the.
ancient
monuments
who knows
what
thread of
ancient
misty past
have
ever appeared
us

S 2

Akiko Kotani
Finca al Rosario
Antigua
Guate.

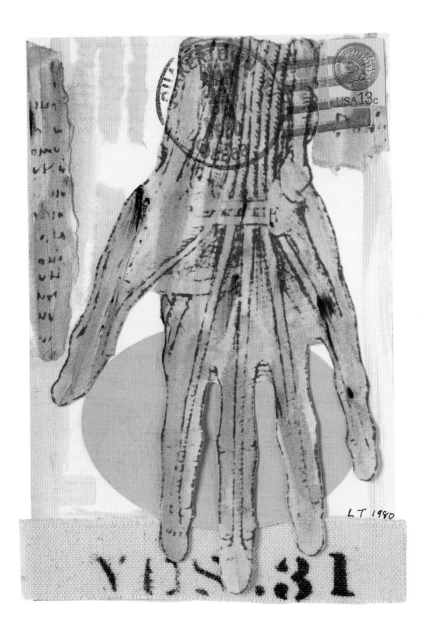

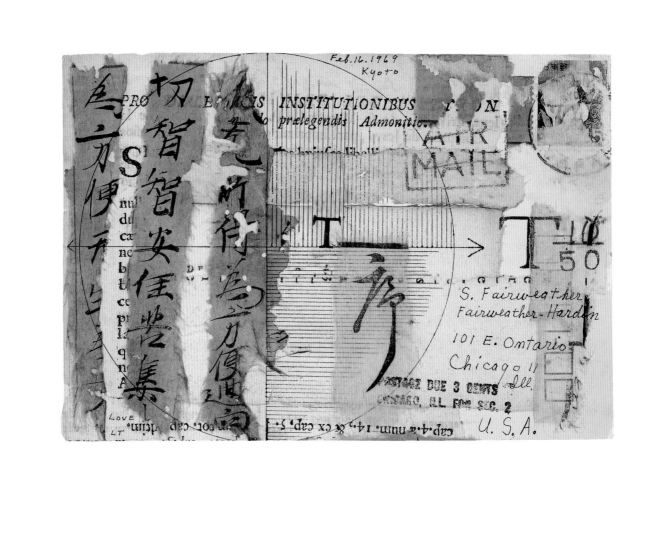

Sabda-brahman

the sound which comes without the
striking of any two things together

(circular handwritten text:) of all beings on the Anahata lotus is red like a Bandhūka flower, here is the sound of Sabda-brahman, the Parabrahman. The Anahata is the quiet Cakra in the heart of...

Kam.
Kham. Gam.
Gham. Nam.
Cam. Cham. Jam.
Jham. Ñam.
Tam. Tham.

the 12
syllables
in the Anahata

Poe Kim
37 East 4
New York, N.Y.

21

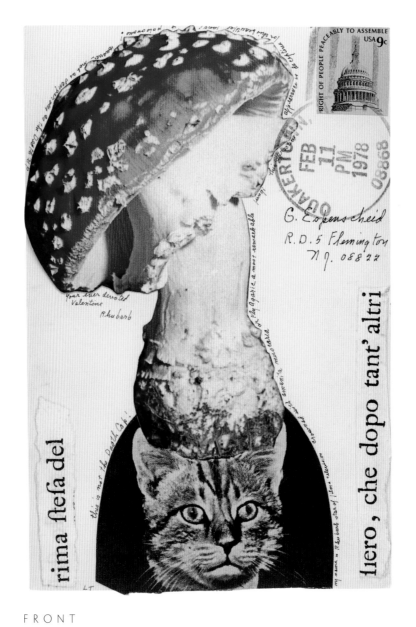

FRONT

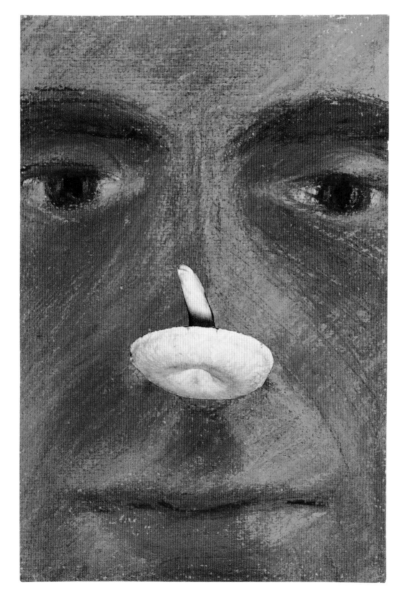

BACK

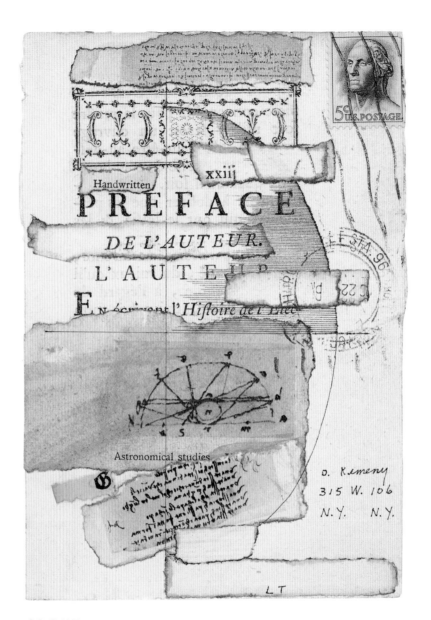

FRONT

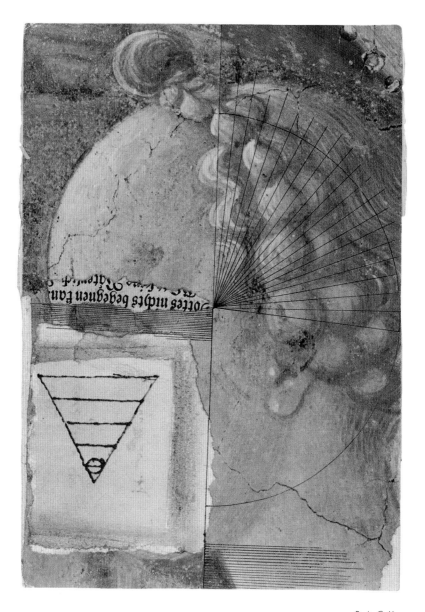

BACK

10.10.80

T. Takaezu
Quakertown
N.J. 08868

Heiltsuk, Bella Bella
Indian Art USA 15c

MESA VERDE NATIONAL PARK, CO
OCT 15 PM 1980 81330

LT

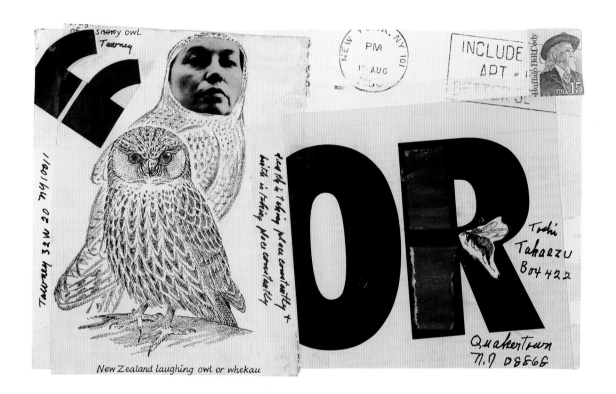

New Zealand laughing owl or whekau

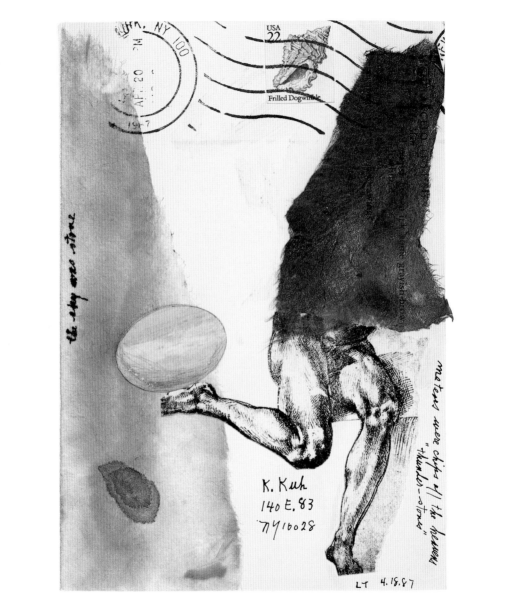

USA
22

Frilled Dogwinkle

the sky was stone

K. Kuh
140 E. 83
NY 10028

matter were chips of the heavens
"thunder-stones"

LT 4.18.87

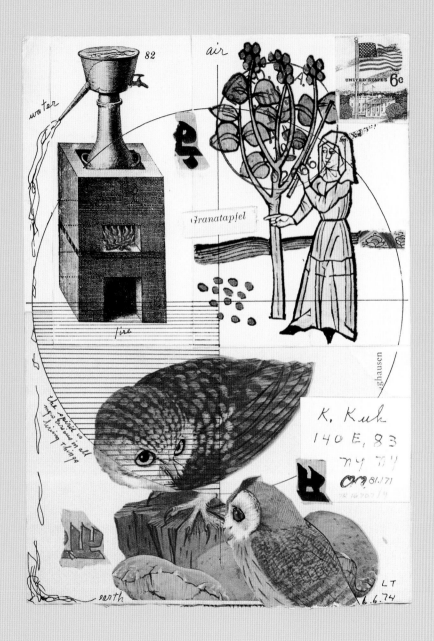

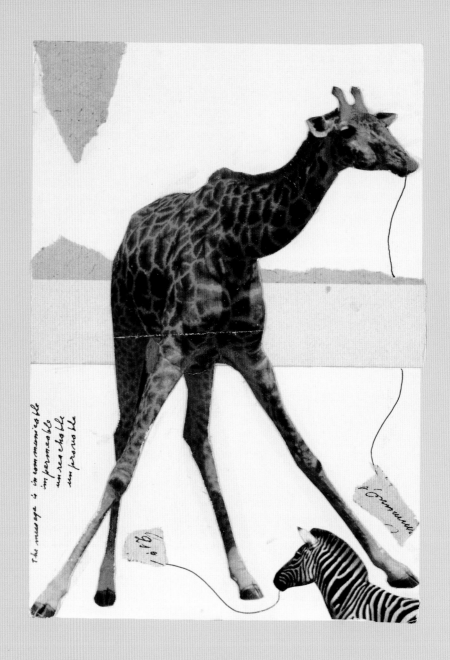

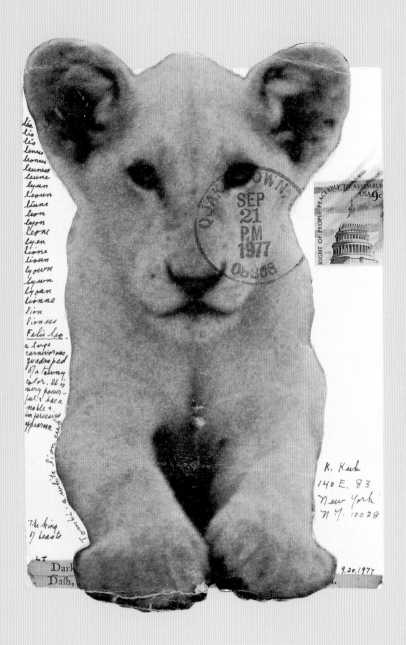

léa
lio
lio
leaea
lioness
leuness
leune
lyen
leoun
liune
leon
lyon
leone
lyen
lione
lioun
lyoun
lyoun
lyoan
lionne
lion
lioness

Felis Leo.
a large
carnivorous
quadroped
of a tawny
color. It is
very power-
ful & has a
noble &
imperious
appearance.

Tony, a white lion cub.

The king
of beasts

Dark
Dash.

O JAKE TOWN
SEP
21
P.M
1977
0 8 5 6 6

RIGHT OF PEOPLE PEACEABLY TO ASSEMBLE
USA 9c

R. Kuh
140 E. 83
New York
N.Y. 10028

9.20.1977

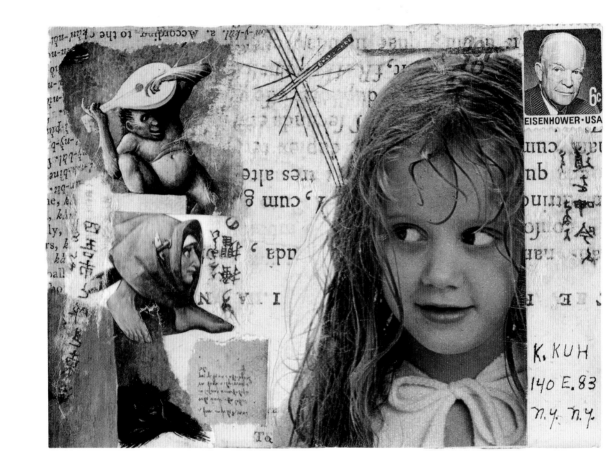

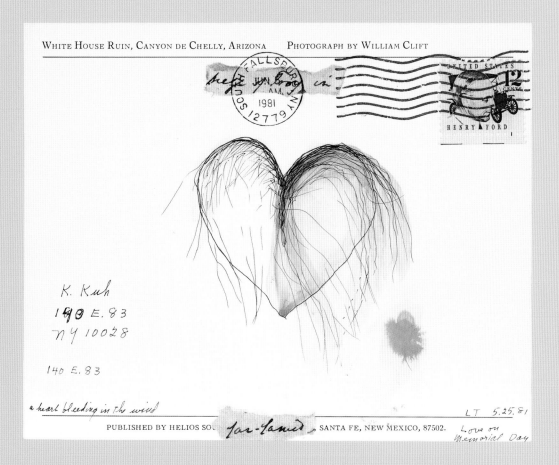

WHITE HOUSE RUIN, CANYON DE CHELLY, ARIZONA PHOTOGRAPH BY WILLIAM CLIFT

K. Kuh
140 E. 83
NY 10028

140 E. 83

a heart bleeding in the wind

LT 5.25.81

PUBLISHED BY HELIOS SOU~~. ~~far-famed~~ ., SANTA FE, NEW MEXICO, 87502. Love on
Memorial Day

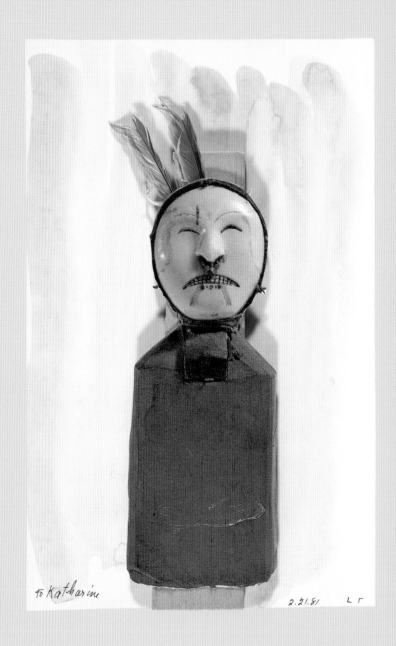

to Katharine 2.21.81 LT

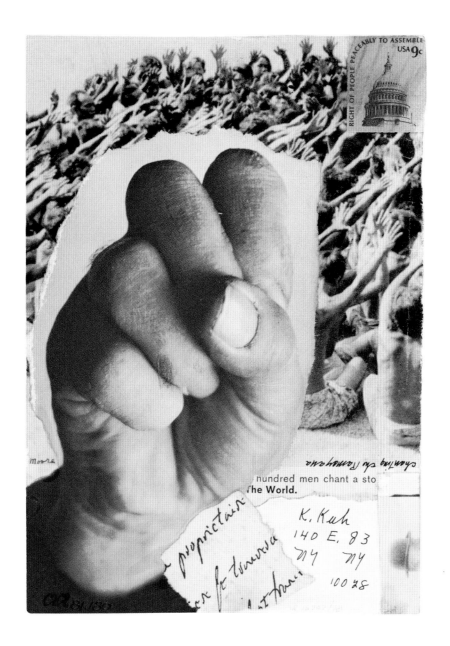

RIGHT OF PEOPLE PEACEABLY TO ASSEMBLE
USA 9c

nundred men chant a sto
he World.

K. Kuh
140 E. 83
ny ny
100 28

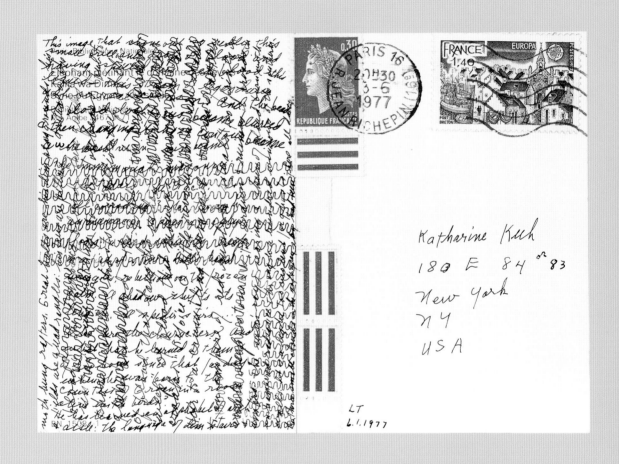

Katharine Kuh
180 E 84 °83
New York
NY
USA

LT
6.1.1977

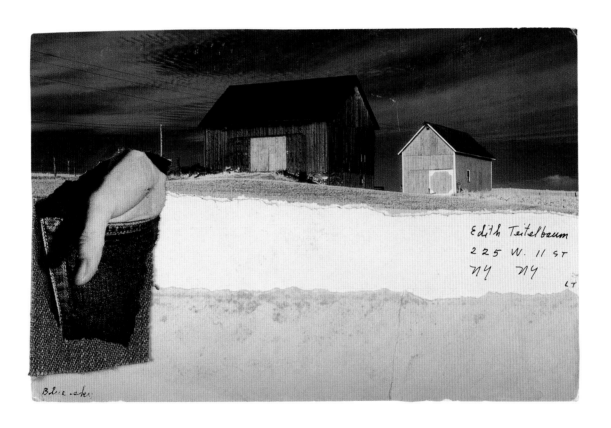

Blue sky

Edith Teitelbaum
225 W. 11 ST
NY NY

LT

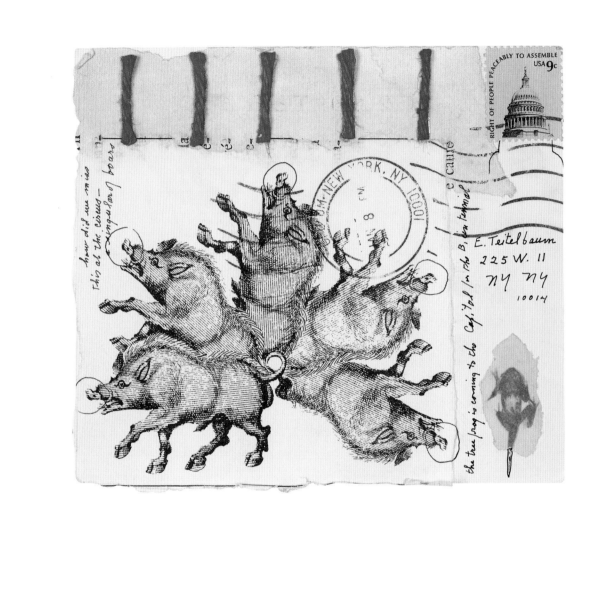

how did we miss
this at the circus—
singulary boars

e caue

E. Teitelbaum
225 W. 11
NY NY
10014

the tree frog is coming to the Capitol in the B, has returned

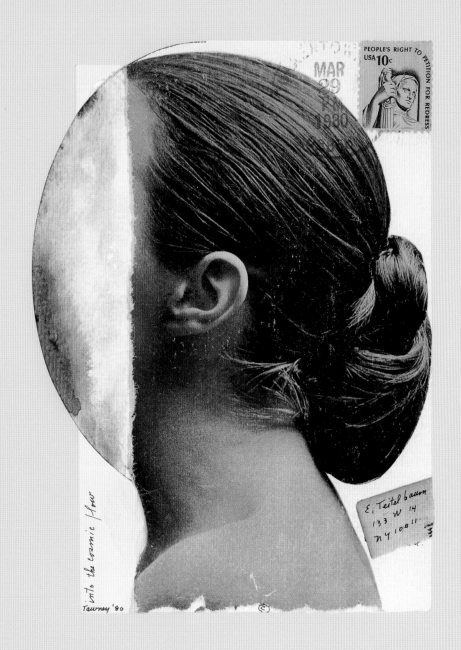

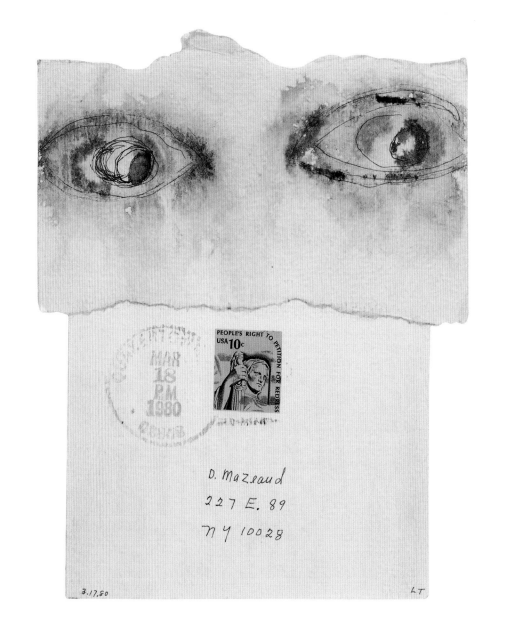

PEOPLE'S RIGHT TO PETITION FOR REDRESS
USA 10c

MAR
18
P.M.
1980

D. Mazeaud
227 E. 89
NY 10028

3.17.80 LT

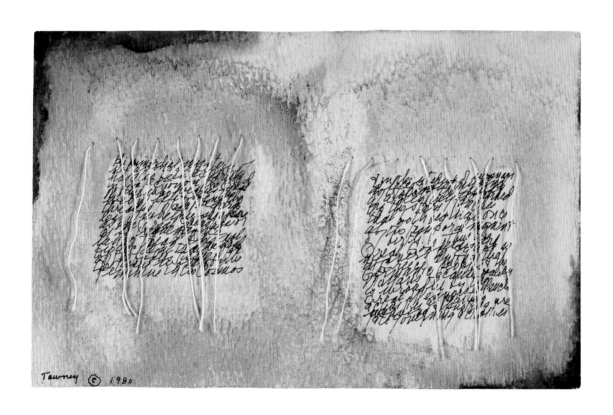

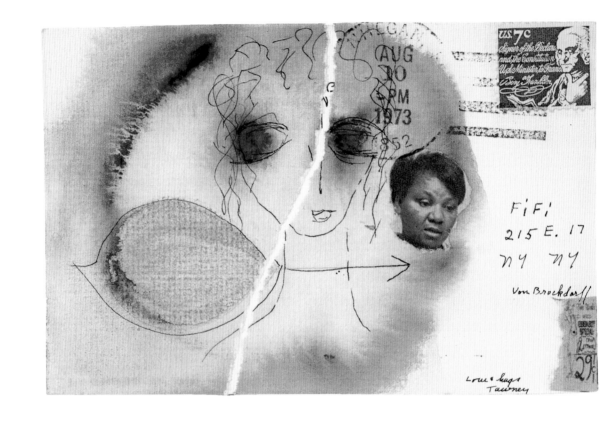

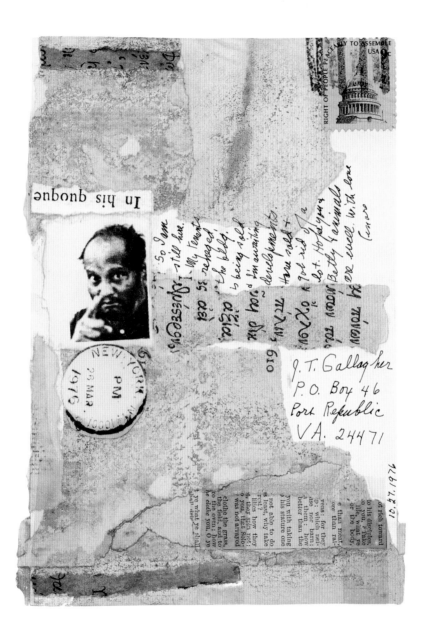

In his quoque

J. T. Gallagher
P.O. Box 46
Port Republic
VA. 24471

10.27.1976

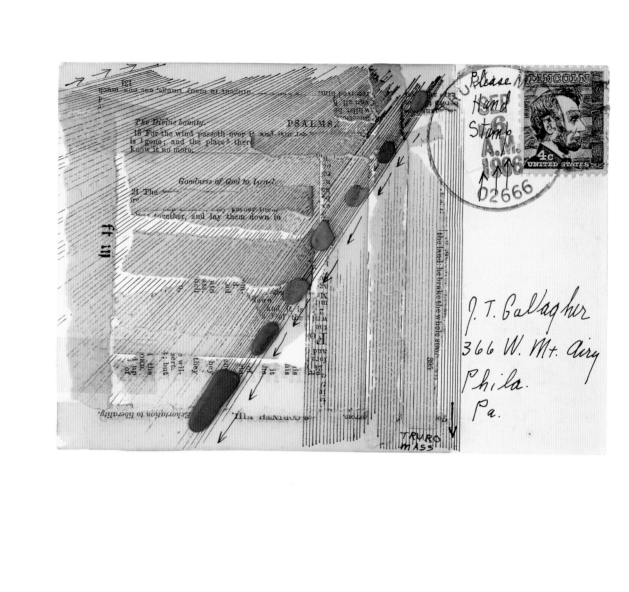

LINCOLN
4c
UNITED STATES

The Divine bounty. PSALMS.

18 For the wind passeth over it, and it
is gone; and the place thereof shall
know it no more:

Goodness of God to Israel.

21 The ...

... together, and lay them down in

Exhortation to liberality.

TRURO
MASS

J. T. Gallagher
366 W. Mt. Airy
Phila.
Pa.

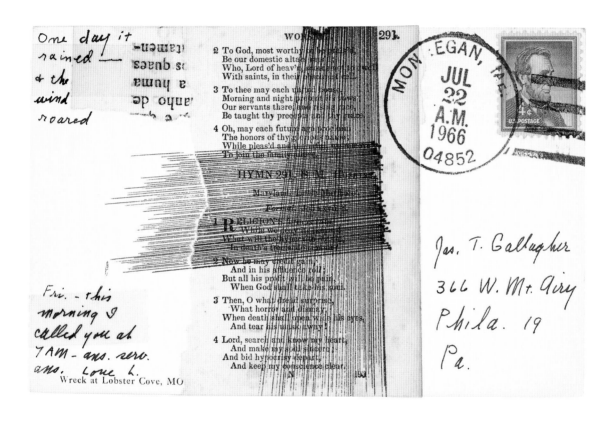

One day it
rained —
& the
wind
roared

Fri. - this
morning I
called you at
7 AM - ans. serv.
ans. Love L.

Wreck at Lobster Cove, MO

WOR... 291.

2 To God, most worthy...
Be our domestic alta...
Who, Lord of heav'n...
With saints, in thei...

3 To thee may each...
Morning and night...
Our servants there...
Be taught thy precepts...

4 Oh, may each future age...
The honors of thy glorious name,
While pleas'd and...
To join the family...

HYMN 291...

Maryland...

1 RELIGION...
While we...
What will the...
In death's...

2 Now he may credit...
And in his affluence roll,
But all his profit will be pain,
When God shall take his soul.

3 Then, O what dread surprise,
What horror and dismay,
When death shall open wide his eyes,
And tear his mask away!

4 Lord, search and know my heart,
And make my soul sincere;
And bid hypocrisy depart,
And keep my conscience clear.

Jas. T. Gallagher
366 W. Mt. Airy
Phila. 19
Pa.

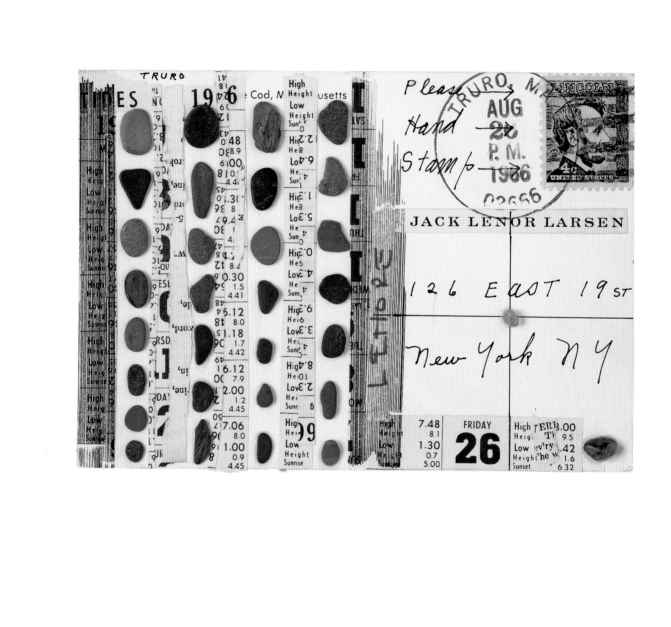

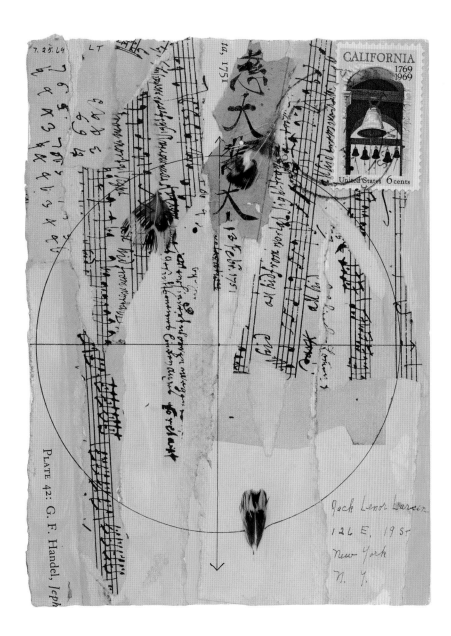

PLATE 42: G. F. Handel, *Jeph*

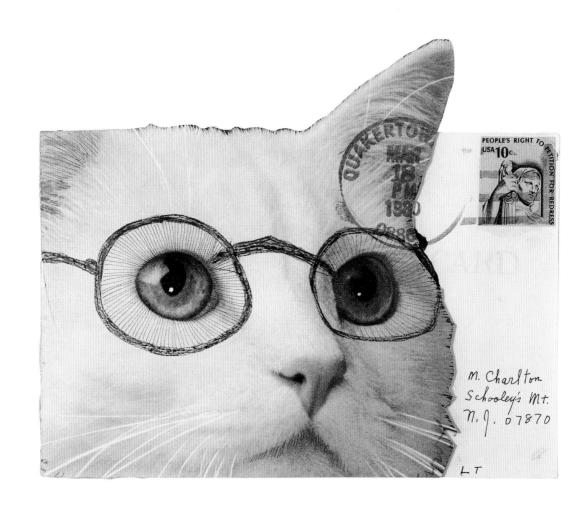

PEOPLE'S RIGHT TO PETITION FOR REDRESS
USA 10c

QUAKERTOWN
MAR
18
PM
1980

m. Charlton
Schooley's Mt.
n. J. 07870

L. T

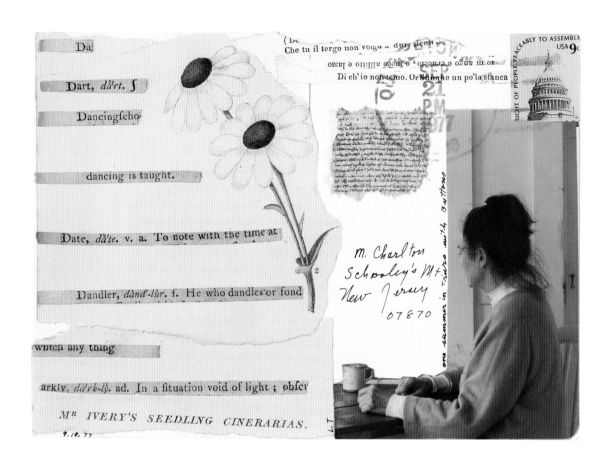

Da

Dart, *dårt.* ſ

Dancingſcho

dancing is taught.

Date, *då'te.* v. a. To note with the time at

Dandler, *dånd'-lŭr.* ſ. He who dandles or fond

witch any thing

arkly. *dårk-lỷ.* ad. In a ſituation void of light ; obſc

M^r IVERY'S SEEDLING CINERARIAS.

9. 10. 77

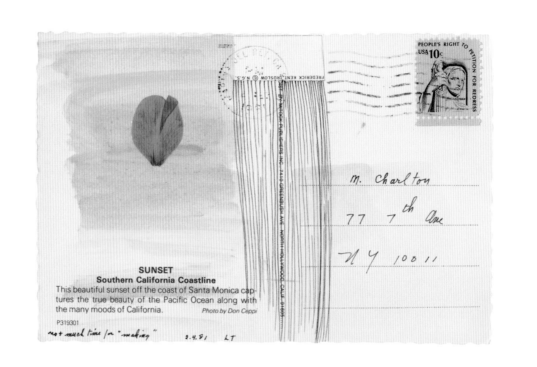

SUNSET
Southern California Coastline
This beautiful sunset off the coast of Santa Monica captures the true beauty of the Pacific Ocean along with the many moods of California. *Photo by Don Ceppi*

P319301

not much time for "making" 2.4.81 LT

M. Charlton

77 7th Ave

N Y 10011

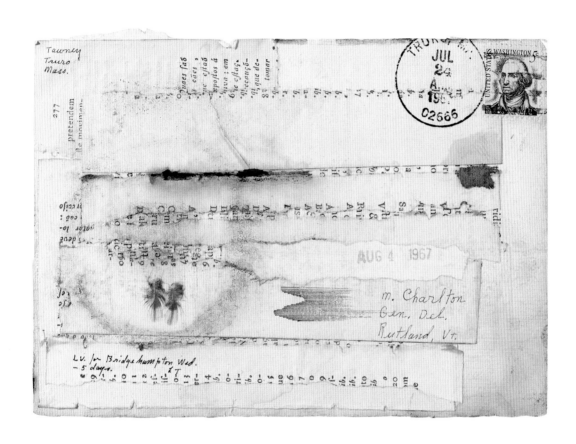

Tawney
Truro
Mass.

m. Charlton
Gen. Del.
Rutland, Vt.

LV. for Bridgehampton Wed.
– 5 days.

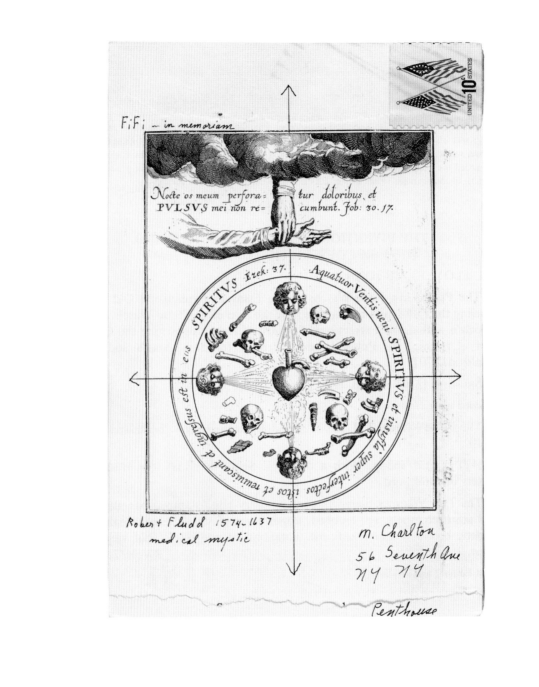

FiFi ~ in memoriam

Robert Fludd 1574-1637
medical mystic

M. Charlton
56 Seventh Ave
NY NY

Penthouse

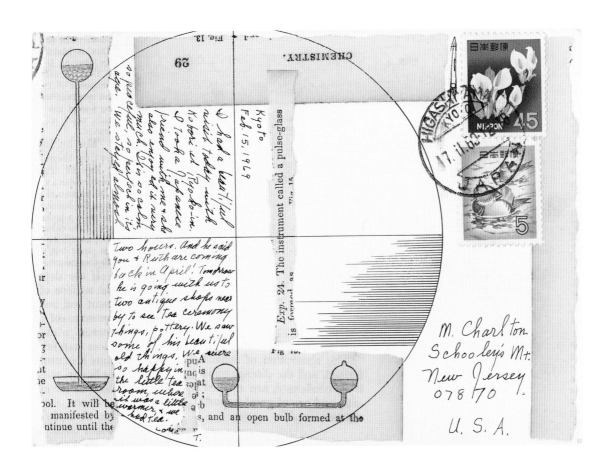

Kyoto
Feb. 15, 1969

① Had a beautiful
visit today with
Kobori at Ryoko-in.
I took a Japanese
friend with me + he
also enjoyed it very
much. Dr. is so calm,
so peaceful, so perfect in its
age. We stayed almost

Two hours. And he said
you + Ruth are coming
back in April! Tomorrow
he is going with us to
two antique shops near
by to see tea ceremony
things, pottery. We saw
some of his beautiful
old things. We were
so happy in
the little tea
room, where
it was a little
warmer + we
had tea.

Love
T.

M. Charlton
Schooley's Mt.
New Jersey
078 70.

U. S. A.

CHEMISTRY.

29

Fig. 13.

Exp. 24. The instrument called a pulse-glass
is formed as

pA...ng is
so at
o;
b
ol. It will be
manifested by
ntinue until the
s, and an open bulb formed at the

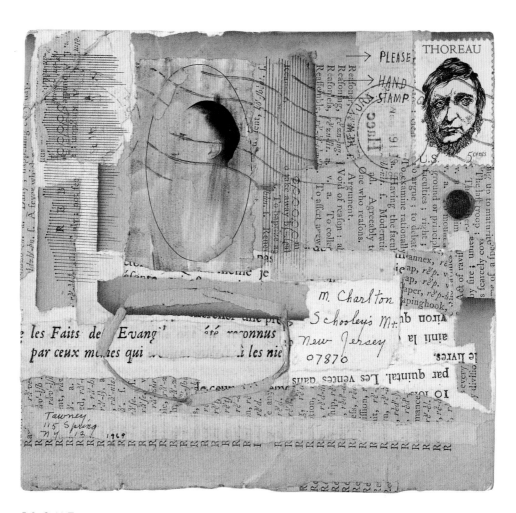

FRONT

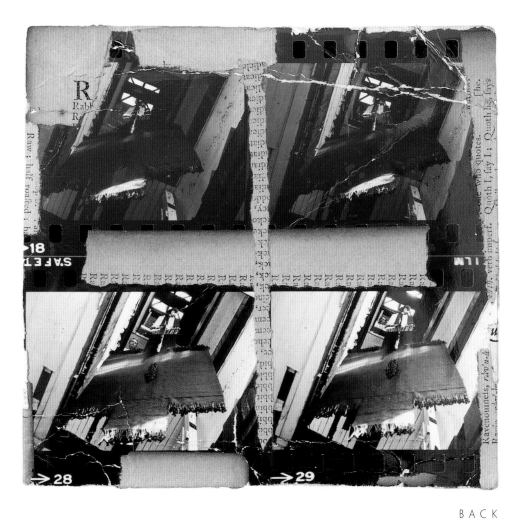

BACK

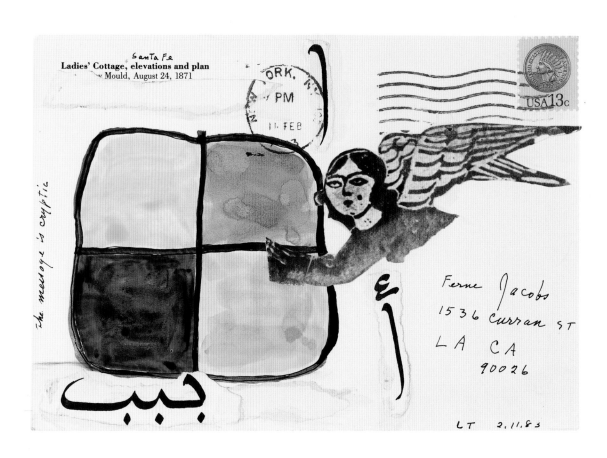

Santa Fe

Ladies' Cottage, elevations and plan
Mould, August 24, 1871

The message is cryptic

USA 13c

جبب

ع ا

Ferne Jacobs
1536 Curran St
LA CA
90026

LT 2.11.83

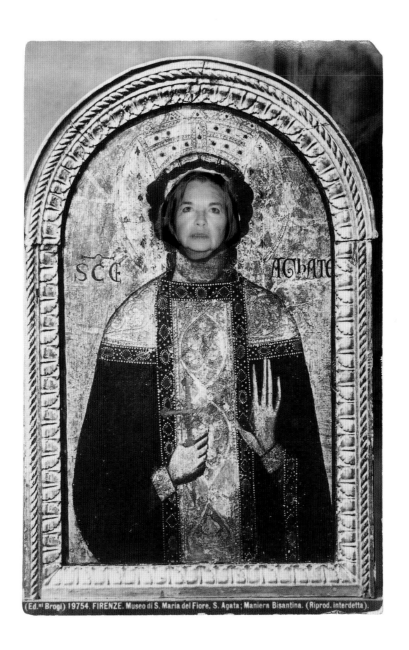

SCE AGATE

(Ed.ˢⁱ Brogi) 19754. FIRENZE. Museo di S. Maria del Fiore, S. Agata; Maniera Bisantina. (Riprod. interdetta).

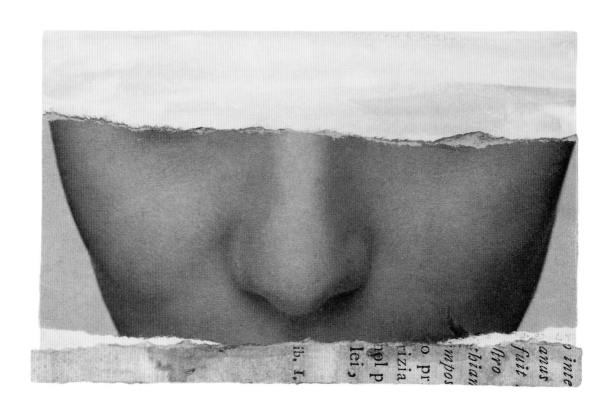

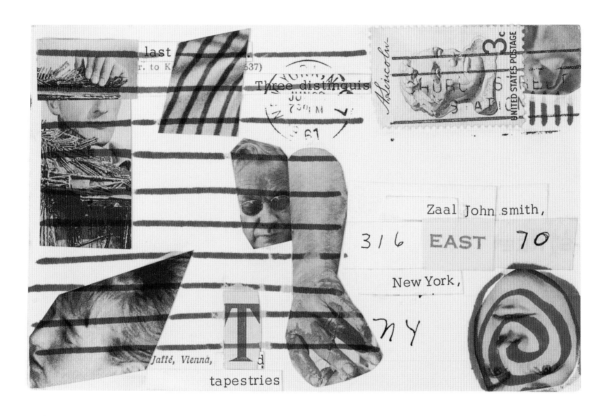

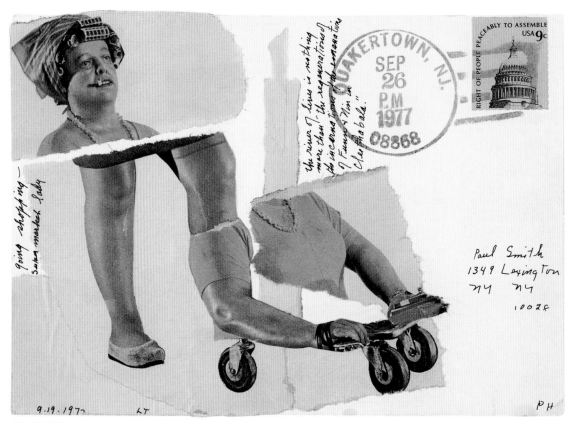

FRONT

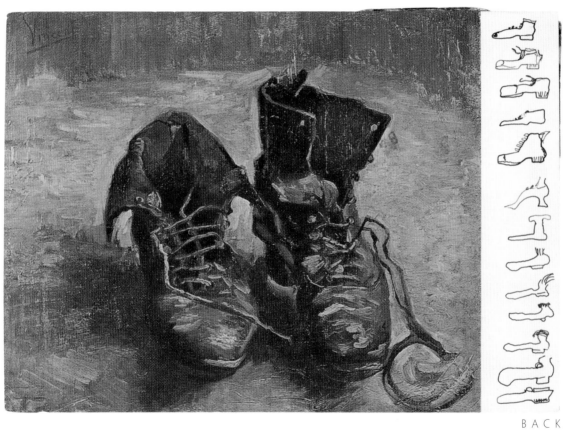

BACK

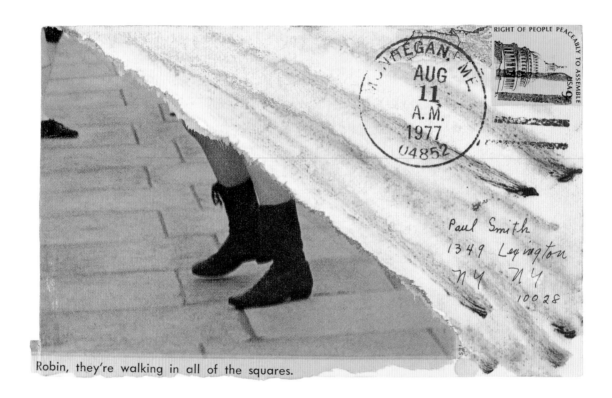

Robin, they're walking in all of the squares.

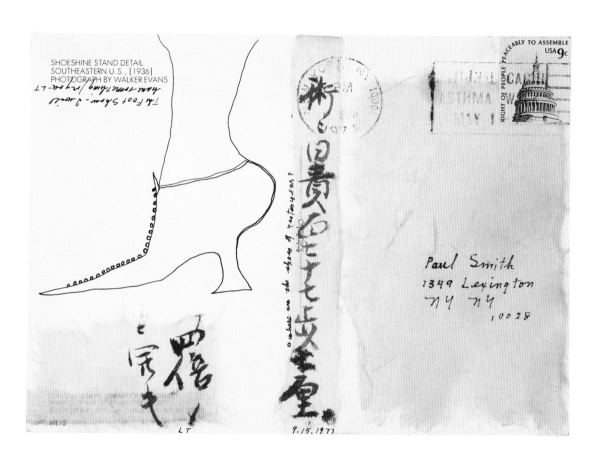

SHOESHINE STAND DETAIL
SOUTHEASTERN U.S., [1936]
PHOTOGRAPH BY WALKER EVANS

Paul Smith
1349 Lexington
NY NY
10028

9.15.1977

It snowed yesterday
"and He said to the
snow, be thou
earth." Job
xxxvii

the Heaven of the Moon
the Heaven of Mercury
the Heaven of Venus
the Heaven of the Sun
the Heaven of Mars
the Heaven of Jupiter
the Heaven of Saturn
The Firmament
The Primum Mobile
the Empyrean Heaven

Paul Smith
1349 Lexington
NY NY
10028

LT 9.19.1977 PH

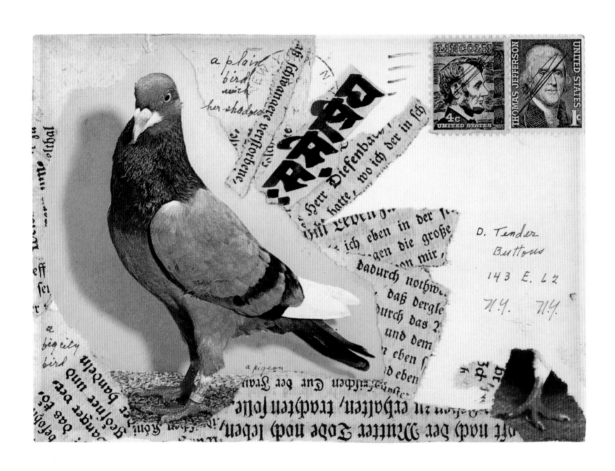

they stick up their paws in civil unhas fashion as they come to a foreplaying dead.

Malka Safro
143 E 62
NY NY

The neck bone is connected to the head bone
the head bone is connected to:

the foot bone is connected to the ankle bone
the ankle bone is connected to the leg bone
the leg bone is connected to the knee bone
the knee bone is connected to the thigh bone
the thigh bone is connected to the hip bone
the hip bone is connected to the back bone
the back bone is connected to the neck bone

147

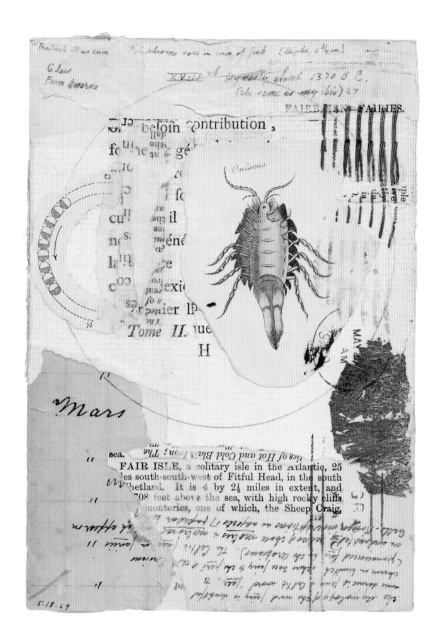

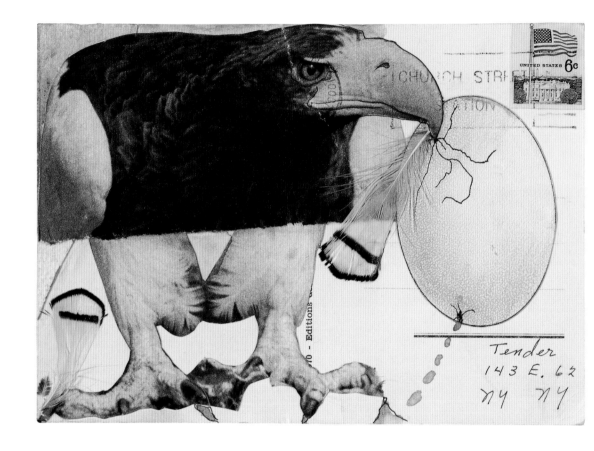

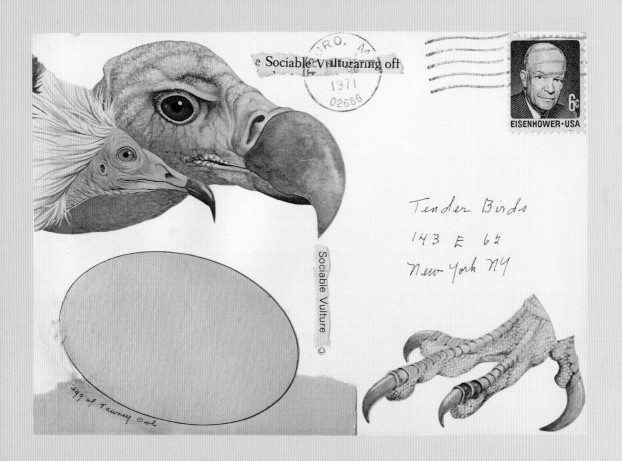

e Sociable Vulturaring off

1971
02666

EISENHOWER · USA
6¢

Sociable Vulture ©

egg of Tawny Owl

Tender Birds
143 E 62
New York NY

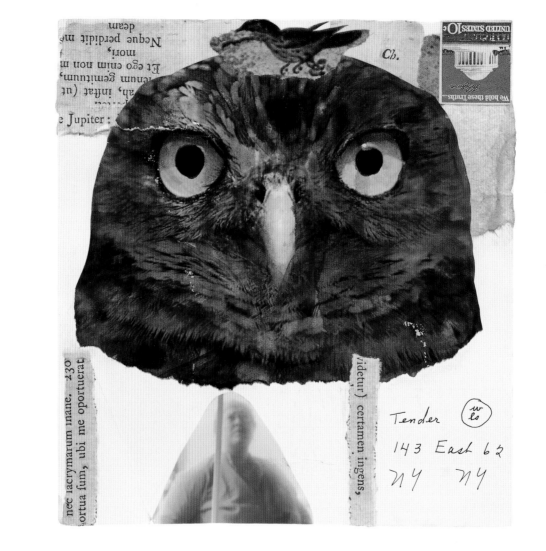

Tender
143 East 62
NY NY

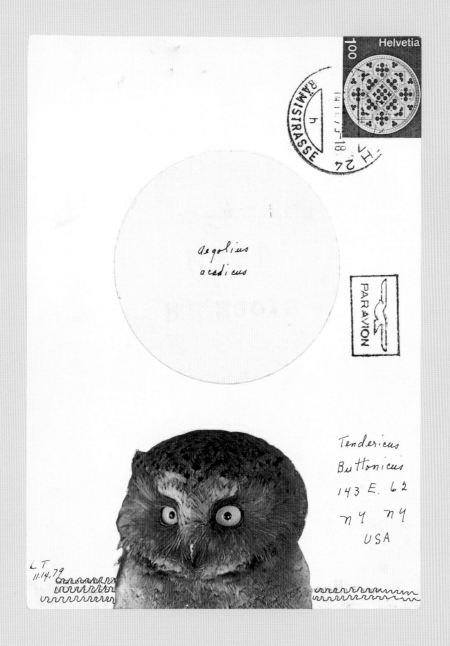

Aegolius
acadicus

PAR AVION

Tendericus
Buttonicus
143 E. 62
ny ny
USA

L.T.
11.14.79

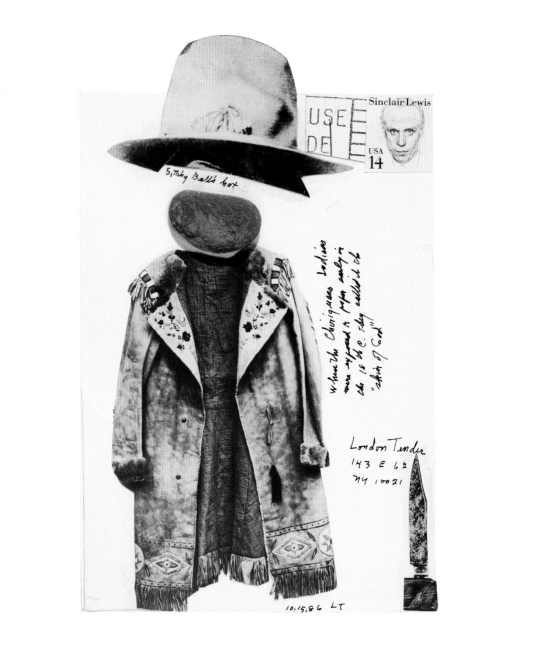

Sitting Bull's hat

Sinclair Lewis
USE
DE
USA
14

where the Chiriguano Indians
were reputed to migrate mostly in
the 18th C. They called it the
"skin of God"

London Tender
143 E 62
NY 10021

10.15.86 LT

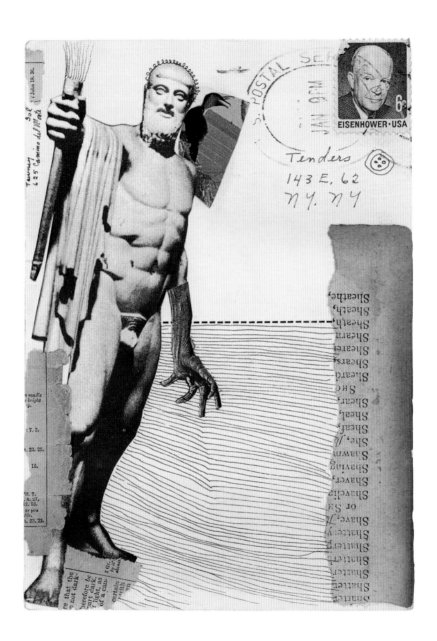

quo, quod est consti

Bag as of New
Flowers blossom
The mountains stand
Trees walk on the
mountains
Batter flies flitter

THE CHARLES W. MORGAN
U.S. 8c

HISTORIC PRESERVATION

80
COR
AE
MEX

II

III

TENDER
TIGERS
143 E. 62
New York
NY USA

the
tiger
walks
(stalks)

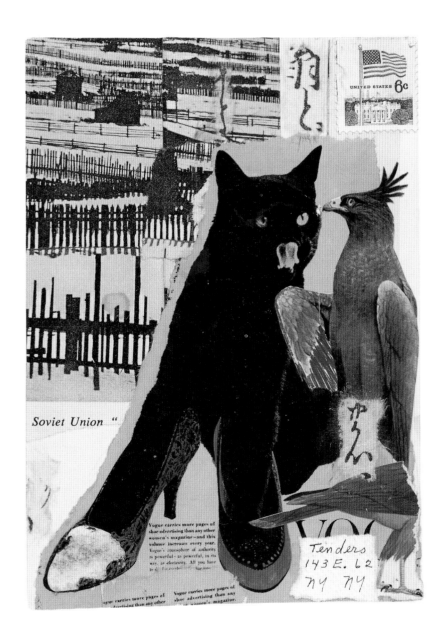

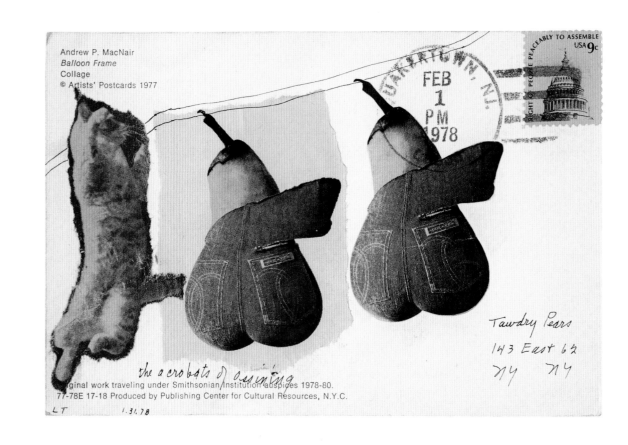

Andrew P. MacNair
Balloon Frame
Collage
© Artists' Postcards 1977

the acrobats of ossining

ginal work traveling under Smithsonian/Institution auspices 1978-80.
77-78E 17-18 Produced by Publishing Center for Cultural Resources, N.Y.C.

LT 1.31.78

Tawdry Pears
143 East 62
NY NY

FEB 1 PM 1978

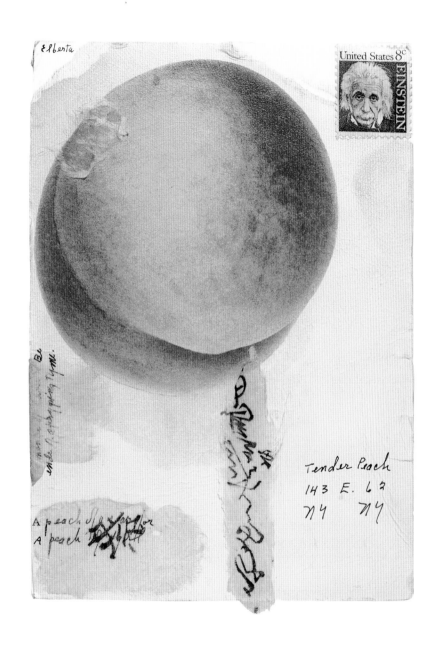

Elberta

A peach of a flavor
A peach

Tender Peach
143 E. 6?
NY NY

nibu... sie animal di...

ens, ergo... atque...

no, Anim... quo u...

au... Transe... bjecti... it re...

orsus... a divi...

pletus bar... omple...

nitcat u... us,... sint

... nom...

exquam... bus... com...

v... tr... no. & *Resp...*

g... i, is... nant...

... um

t... *Hom...* est

... pu... T... hr...

... aut *simplex*

c... sit... kpertem, ut eu

n... n... gnificat rem... o,

Co... *em, Populus, Exerci*

po... e pure moralis, qualis

... vel quatern... al,

E... vel quatenu... desce... en...

Ite... ea copulatio possite...

37 ... ut *cœtus* ba...

plic... ad altium

... mor, ve...

...is possi...

... sic

... og...

... ta u...

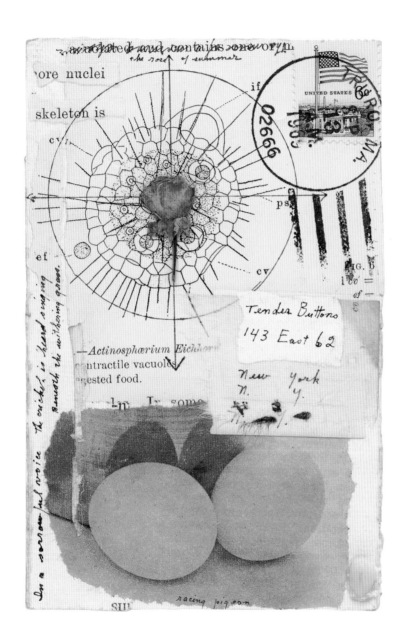

Truro, Mass.

Lenore Tawney
exhibition of
August 24 - September 9, 1969

4-7 PM of Electricity.

Benson Gallery Bridgehampton

AGENCIES OF AIR.

ulics and pneumatics, and there
nt of such ines to the pr

ois d
emens qui signa
ce mois, O
ptembre Oc
an orifice
red in throu ont
the bend. Th ent
e : for quorn, est a
urges & D ? a

on Cybele? Fr
oient its appetes
Fig. 92

Fig. 85.

arms, a longe
e Syphon.
opening being closed,
he plugs removed and

LT
5-12-68

sting tube.
eratio

FACTS, which
an alle avoit le titre

water, a
is imm

which is left on the moon

uction tube. I

TRU
JUL
M
1969
02666

THOMAS JEFFERSON UNITED STATES 1¢

WASHINGTON 5¢
UNITED STATES

Diana Epstein
143 E. 62
New York
N. Y.

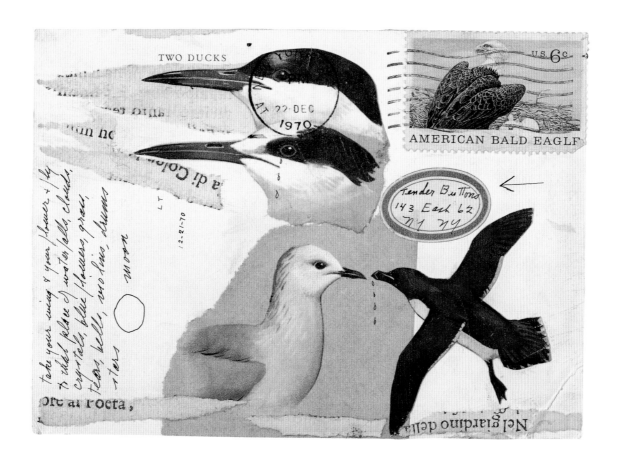

TWO DUCKS

YOU

AT 22·DEC

1970

US 6c

AMERICAN BALD EAGLE

Tender Buttons
143 East 62
NY NY

Nel giardino della

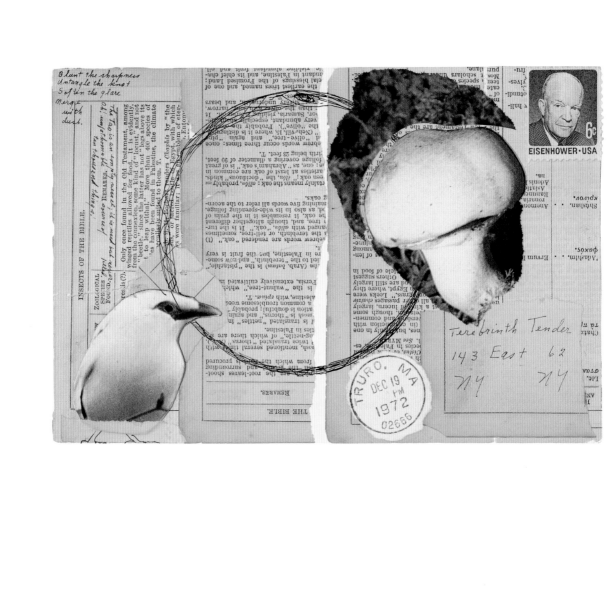

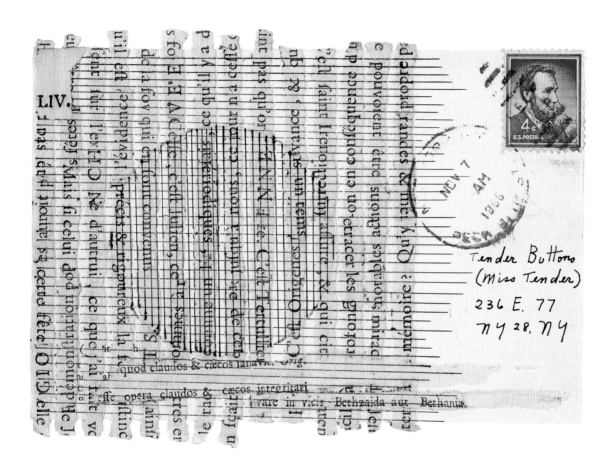

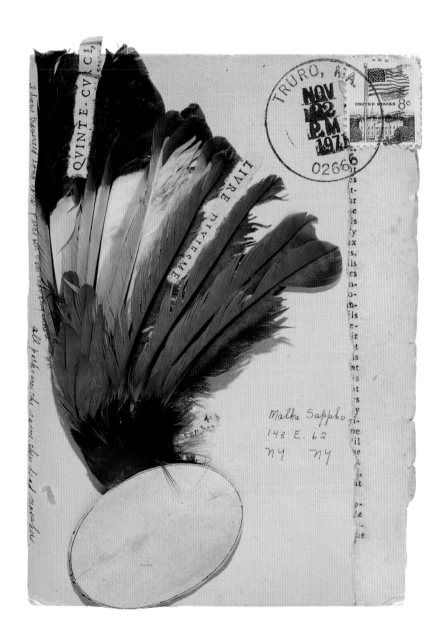

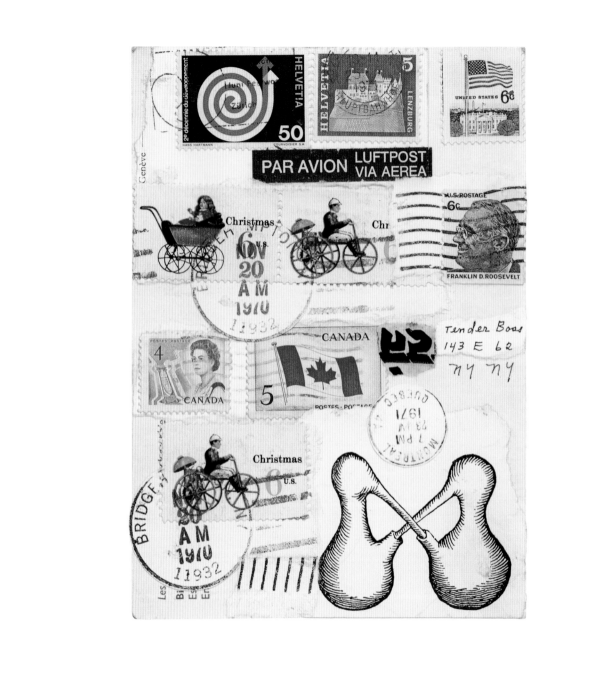

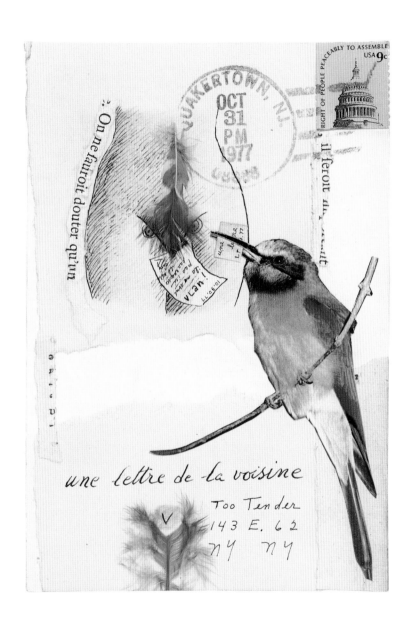

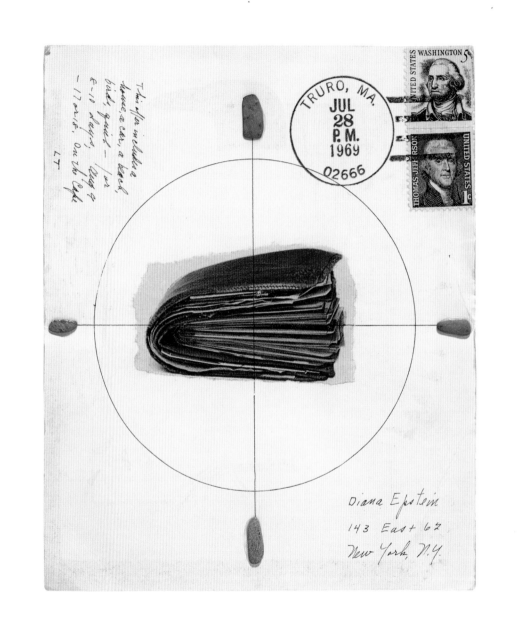

This reflex included a
house, a car, a beach,
birds, quiet — 1 or 2
6—10 hours, Aug 9
— 17 or 18. On the Cape.
LT

TRURO, MA.
JUL
28
P.M.
1969
02666

Diana Epstein
143 East 62
New York, N.Y.

Tibet
under
Jerusa.
lem

1980
Tawney
©

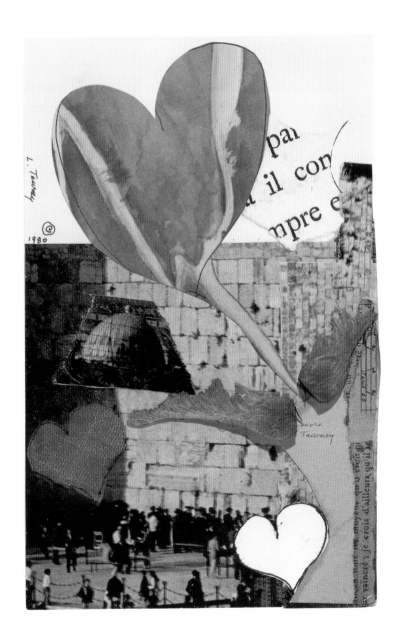

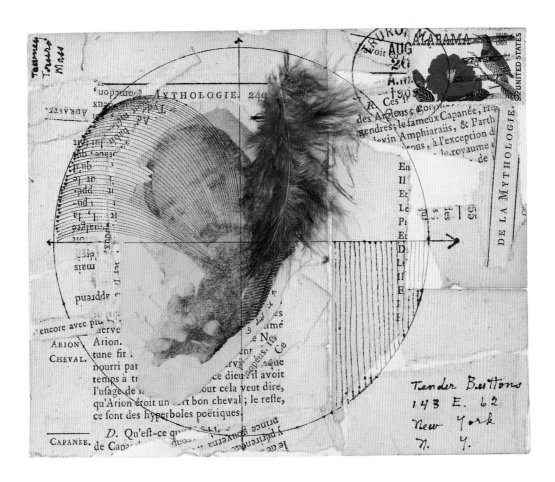

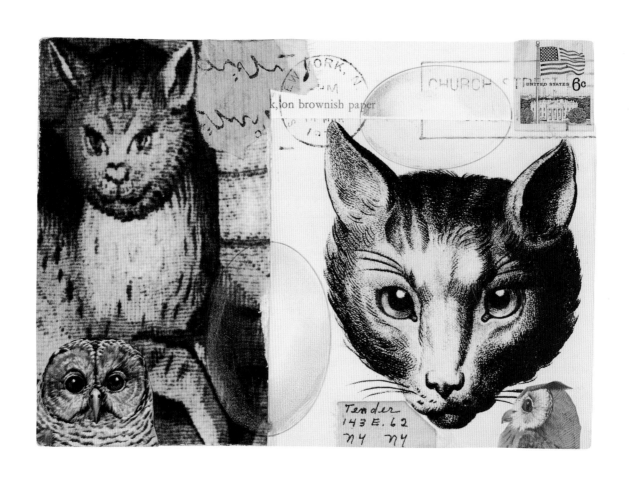

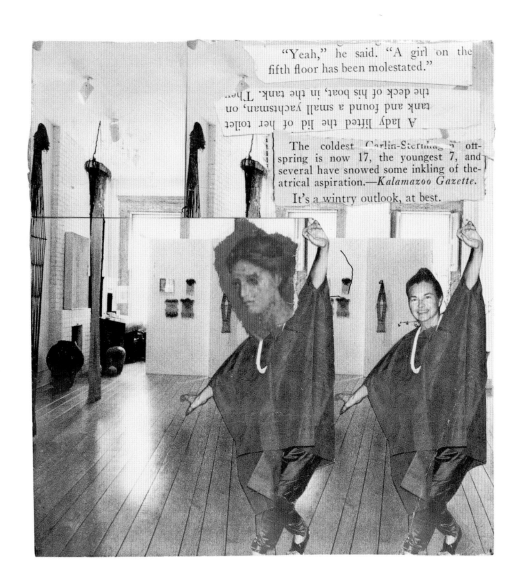

"Yeah," he said. "A girl on the fifth floor has been molested."

A lady lifted the lid of her toilet tank and found a small yachtsman, on the deck of his boat, in the tank. The...

The coldest Carlin-Sterling offspring is now 17, the youngest 7, and several have snowed some inkling of theatrical aspiration.—*Kalamazoo Gazette*.

It's a wintry outlook, at best.

ACKNOWLEDGMENTS

Thanks are due to many individuals who contributed their time and talents to this project, including the recipients of the postcards, who have treasured and preserved them and generously made them available for this book, especially Nancy Azara; Maryette Charlton; Diana Epstein and Millicent Safro; Carter Foster, Associate Curator of Drawings at The Cleveland Museum of Art; James T. Gallagher; Ferne Jacobs; Robert Kushner; Dominique Mazeaud; Edith Isaac Rose; Toshiko Takaezu; and Paul J. Smith.

Appreciation is also due to Holland Cotter for contributing the essay; to George Erml for his photographs of the cards; and to Kathleen Nugent Mangan, who conceived of this project and has been so instrumental in its development. halley k harrisburg and Michael Rosenfeld of the Michael Rosenfeld Gallery wholeheartedly supported this book and introduced Lenore Tawney to Pomegranate.

At Pomegranate, Katie Burke, publisher, demonstrated immediate and unflagging enthusiasm for this book. Harrah Lord was responsible for the design; and Lisa Reid, art director, supervised the design during the production process.

Lenore Tawney wishes to acknowledge "with deepest appreciation and love" her meditation teachers, Swami Muktananda and Swami Chidvilasananda.